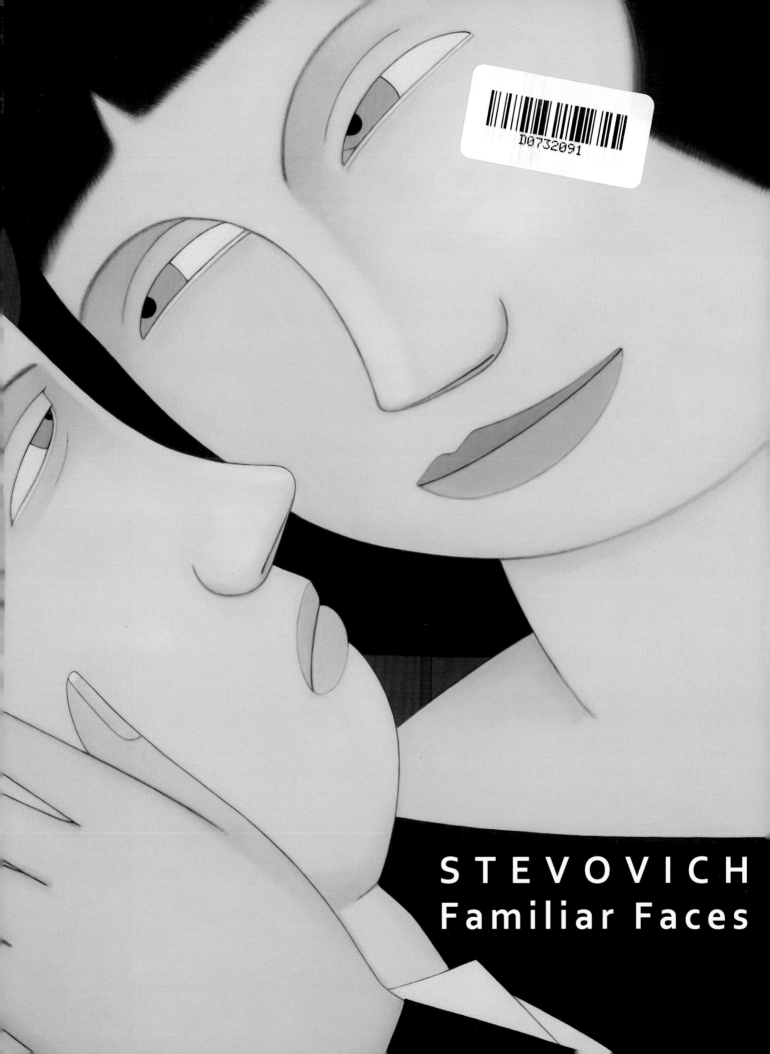

STEVOVICH
Familiar Faces

ANDREW STEVOVICH
Familiar Faces

Paintings

Anne at the Window, 2013
Oil on linen, 5 1/4 x 3 inches

$5,500

Blackjack Players, 2012
Oil on linen, 28 x 42 inches

$75,000

Cellphones, 2012
Oil on linen, 15 x 15 inches

Private Collection

Chocolate Truffles, 2013
Oil on linen, 12 x 7 1/4 inches

$12,000

Coffee, 2012
Oil on linen,
Diptych 6 x 4 1/2 inches each panel
$12,000

Dinner in Ithaca, 2011
Oil on linen, 25 x 30 inches

$45,000

Dragonfly, 2014
Oil on linen, 6 1/2 x 3 1/4 inches

Private Collection

Hamburger at Rosie's, 2011
Oil on linen, 16 x 18 inches

$25,000

Heidi's Birdhouse, 2014
Oil on linen, 18 x 15 inches

$25,000

Interior at Night, 2013
Oil on linen, 52 x 50 inches

$95,000

Lola Too, 2014
Oil on linen, 7 x 7 1/2 inches

$8,500

Loretta Sleeping, 2013
Oil on linen, 8 1/4 x 10 inches

$12,000

Lunch in Ithaca, 2011
Oil on linen, 27 x 30 inches

$45,000

Man Wearing a Grey Hat, 2014
Oil on linen, 4 3/4 x 4 1/4 inches

$5,500

Marko, 2013
Oil on linen, 6 1/4 x 4 1/2 inches

$6,500

Mookie, 2014
Oil on linen, 6 1/2 x 4 inches

Private Collection

Movie, 2014
Oil on linen, 45 x 75 inches

$120,000

Mr. Epps, 2014
Oil on linen, 16 x 12 inches

$18,000

Nauset Beach, 2013
Oil on linen, 7 x 4 inches

$6,000

Number Game, 2011
Oil on linen, 20 x 20 inches

$35,000

Ollie's Pizza, 2010
Oil on linen, 16 3/4 x 12 inches

$18,000

Red Beret, 2012
Oil on linen, 5 1/2 x 4 inches

$6,000

Sophie, 2012
Oil on linen, 42 x 27 inches

$75,000

Suki with a Note, 2012
Oil on linen, 4 1/2 x 3 3/4 inches

$5,500

Subway: East Street Station, 2011
Oil on linen, 10 x 10 inches

$12,500

Subway Riders, 2014
Oil on linen, 30 x 40 inches, 2014

$75,000

Woman Wearing a Red Hat, 2014
Oil on linen, 16 x 10 inches

$18,000

Woman with a Grey Cat, 2014
Oil on linen, 11 1/2 x 9 1/2 inches

SOLD

Woman with a Large Envelope, 2013
Oil on linen, 7 x 4 1/2 inches

SOLD

Woman with Camcorder, 2013
Oil on linen, 6 x 3 3/4 inches

$6,000

Drawings

Cellphone, Drawing #3, 2012
Pencil on graph paper
7 1/4 x 9 inches

$1,500

Cellphones (Transfer Drawing), 2012
Pencil on paper with pastel tone on reverse
15 x 15 inches

$4,500

Lola Too (Transfer Drawing), 2014
Pencil on paper with pastel tone on reverse
7 x 7 1/2 inches

$1,500

Marko, Drawing #3, 2013
Pencil on graph paper
5 1/2 x 4 inches

$1,000

Movie (Drawing), 2014
Pencil on paper
24 x 40 inches

$6,000

Sophie Drawing #2, 2012
Pencil on paper
30 x 16 inches

$5,000

Subway Riders, Drawing, 2014
Pencil on graph paper
10 x 13 inches

$2,500

ADELSON GALLERIES

Adelson Galleries | The Crown Building, 730 Fifth Avenue, 7th Floor, New York NY | 212.439.6800 | info@adelsongalleries.com

Adelson Galleries Boston | 520 Harrison Avenue, Boston MA | 617.832.0633 | info@adelsongalleriesboston.com

ANDREW STEVOVICH
Familiar Faces

Paintings

Anne at the Window, 2013
Oil on linen, 5 1/4 x 3 inches
$5,500

Blackjack Players, 2012
Oil on linen, 28 x 42 inches
$75,000

Cellphones, 2012
Oil on linen, 15 x 15 inches
Private Collection

Chocolate Truffles, 2013
Oil on linen, 12 x 7 1/4 inches
$12,000

Coffee, 2012
Oil on linen,
Diptych 6 x 4 1/2 inches each panel
$12,000

Dinner in Ithaca, 2011
Oil on linen, 25 x 30 inches
$45,000

Dragonfly, 2014
Oil on linen, 6 1/2 x 3 1/4 inches
Private Collection

Hamburger at Rosie's, 2011
Oil on linen, 16 x 18 inches
$25,000

Heidi's Birdhouse, 2014
Oil on linen, 18 x 15 inches
$25,000

Interior at Night, 2013
Oil on linen, 52 x 50 inches
$95,000

Lola Too, 2014
Oil on linen, 7 x 7 1/2 inches
$8,500

Loretta Sleeping, 2013
Oil on linen, 8 1/4 x 10 inches
$12,000

Lunch in Ithaca, 2011
Oil on linen, 27 x 30 inches
$45,000

Man Wearing a Grey Hat, 2014
Oil on linen, 4 3/4 x 4 1/4 inches
$5,500

Marko, 2013
Oil on linen, 6 1/4 x 4 1/2 inches
$6,500

Mookie, 2014
Oil on linen, 6 1/2 x 4 inches
Private Collection

Movie, 2014
Oil on linen, 45 x 75 inches
$120,000

Mr. Epps, 2014
Oil on linen, 16 x 12 inches
$18,000

Nauset Beach, 2013
Oil on linen, 7 x 4 inches
$6,000

Number Game, 2011
Oil on linen, 20 x 20 inches
$35,000

Ollie's Pizza, 2010
Oil on linen, 16 3/4 x 12 inches
$18,000

Red Beret, 2012
Oil on linen, 5 1/2 x 4 inches
$6,000

Sophie, 2012
Oil on linen, 42 x 27 inches
$75,000

Suki with a Note, 2012
Oil on linen, 4 1/2 x 3 3/4 inches
$5,500

Subway: East Street Station, 2011
Oil on linen, 10 x 10 inches
$12,500

Subway Riders, 2014
Oil on linen, 30 x 40 inches, 2014
$75,000

Woman Wearing a Red Hat, 2014
Oil on linen, 16 x 10 inches
$18,000

Woman with a Grey Cat, 2014
Oil on linen, 11 1/2 x 9 1/2 inches
SOLD

Woman with a Large Envelope, 2013
Oil on linen, 7 x 4 1/2 inches
SOLD

Woman with Camcorder, 2013
Oil on linen, 6 x 3 3/4 inches
$6,000

Drawings

Cellphones (Transfer Drawing), 2012
Pencil on paper with pastel tone on reverse
15 x 15 inches
$4,500

Cellphone, Drawing #3, 2012
Pencil on graph paper
7 1/4 x 9 inches
$1,500

Lola Too (Transfer Drawing), 2014
Pencil on paper with pastel tone on reverse
7 x 7 1/2 inches
$1,500

Marko, Drawing #3, 2013
Pencil on graph paper
5 1/2 x 4 inches
$1,000

Movie (Drawing), 2014
Pencil on paper
24 x 40 inches
$6,000

Sophie Drawing #2, 2012
Pencil on paper
30 x 16 inches
$5,000

Subway Riders, Drawing, 2014
Pencil on graph paper
10 x 13 inches
$2,500

ADELSON GALLERIES

Adelson Galleries | The Crown Building, 730 Fifth Avenue, 7th Floor, New York NY | 212.439.6800 | info@adelsongalleries.com

Adelson Galleries Boston | 520 Harrison Avenue, Boston MA | 617.832.0633 | info@adelsongalleriesboston.com

ANDREW STEVOVICH
Familiar Faces

Boston
February 6th - March 15, 2015

New York
March 24th - April 25th, 2015

Adelson Galleries Boston

520 Harrison Avenue

Boston, MA 02118

617.832.0633

www.adelsongalleriesboston.com

Adelson Galleries

The Crown Building, 730 Fifth Avenue, 7th Floor

New York, NY 10019

212.439.6800

www.adelsongalleries.com

ADELSON GALLERIES

Adam Adelson

Familiar Faces

I have been surrounded by Andrew Stevovich's work my entire life. In the house I grew up in, my parents hung Sargent and Cassatt in the living room, and Stevovich in the kitchen, where our family spent most of their time. I have fond memories of relating to these quiet pictures while I was eating. I imagined that the *Woman with a Fishbowl* (1996, figure 1) depicted a narrative of my pet, Goldie, and the menacing previous owner who seemed ready to torment my poor goldfish with her net. As a child, I saw simplicity in Andrew's oils. I understood them to be more familiar than the cartoons I watched on Saturday mornings; yet, like the cartoons, the imagery represented daily life in a colorful and entertaining manner. Now, as an adult, I see the complexity of his soft, linen canvases. I see the intricacy of composition and technique, as well as the density of his subject matter.

The underlying complexities of Stevovich's process contrasts with the flatness of his characters. What at first seems simple about these paintings becomes elaborate when investigated thoroughly. Compositionally, the people and objects are very carefully designed. Often using the Fibonacci ratio (a mathematical formula derived from biological forms), the artist arranges curved and straight lines in a way that simultaneously balances the canvas and expands the image beyond the frame. Stylistically, his figures seem casually drawn — given their ethereal appearance; however, the artist painstakingly applies each line with deliberate precision. By shifting the angle of the parabola that separates the lips of a mouth or curve of an eye, Stevovich achieves a range of emotion with a very minimal approach.

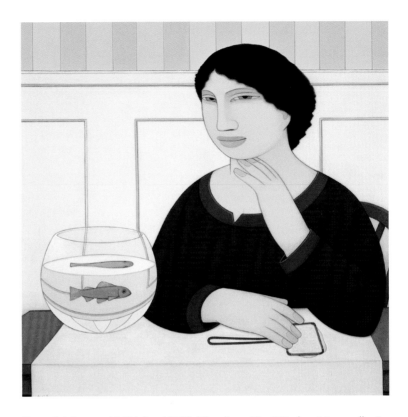

Figure 1. *Woman with Fish Bowl*, 1996, Oil on linen, 18 x 18 inches. Private collection

The negative space that fills between the features of his figures' faces transform the paintings into mirrors. The lack of wrinkles, skin spots, or other facial imperfections allows viewers to identify psychologically rather than compare with the physiognomy. I see myself in them. I react in recognition of modest pleasures or empathize with multifaceted pains. Depending on my mood, I read the inconclusive narrative of each scene with varying responses. For example, at one moment in the day, I may perceive *Woman with a Grey Cat* (2014, page 50) as a hopeful allegory for living alone in peace, and fifteen minutes later, I will look at her again with a feeling of mutual loneliness. For me, each representation evokes a cluster of assorted sentiments from eroticism and envy to anger and boredom. I find the character of these polished paintings allows intimate, personal responses due to their absence of idiosyncratic attributes.

Occasionally, Stevovich repeats themes that resonate with him. One relevant example is his triptych, *Lola* (2005, figure 2), a predecessor to a few recent artworks. The artist frames a couple in an amorous entanglement, and places two other couples in separate panels, in their own worlds, adjacent to the embracing pair. The strangers, who have walked in on this private moment, have similar reactions — gesticulating a hand, looking away, or glancing towards the lovers with envy.

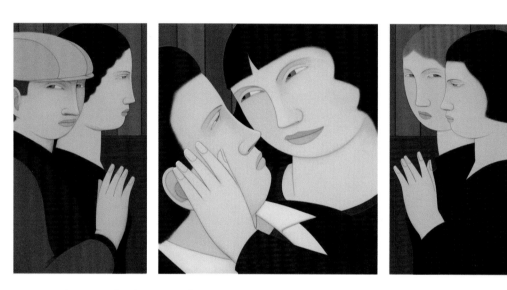

Figure 2. *Lola*, 2005, Oil on linen, Triptych, 20 x 11, 20 x 18, 20 x 11 inches

In Stevovich's more recent, singular portrayal, *Lola Too* (2014, page 17), he removes the voyeurs, and forces the viewer to have their own response. On this smaller scale, one can look closely into this encased view and read the glance between them. The artist's most recent creation, *Movie* (2014, page 10), places us, the spectators, in a crowd as one of many. We are in the movie theater. A few of Stevovich's prior pieces have led up to this moment. One composition illustrates moviegoers buying tickets. Another depicts the crowd rushing to devour popcorn before the film. A third shows

the audience politely racing on the stairs to claim the best seats. Finally, we are inside, and we see a narrative on the screen that the artist has been alluding to for years — the embracing couple with an uncertain relationship.

The theme of the theater reminds us that we are all observers of one another. We are constantly looking at pictures of others and comparing our perception of them with ourselves. The theater has traditionally been the arena to celebrate this innate human curiosity. Stevovich exposes this fact, and reminds us that we are not as unique as we think. Although we all see through different eyes, we share a common bond through similar passions and desires.

Celebrating a nearly 35-year relationship with the artist, Adelson Galleries will, for the first time, exhibit *Familiar Faces* in both Boston and New York locations. The exhibition includes paintings and drawings from the last few years, which exemplifies Stevovich's distinctive style and exposes his willingness to take new risks in scale, perspective, and subject. We hope you enjoy the show.

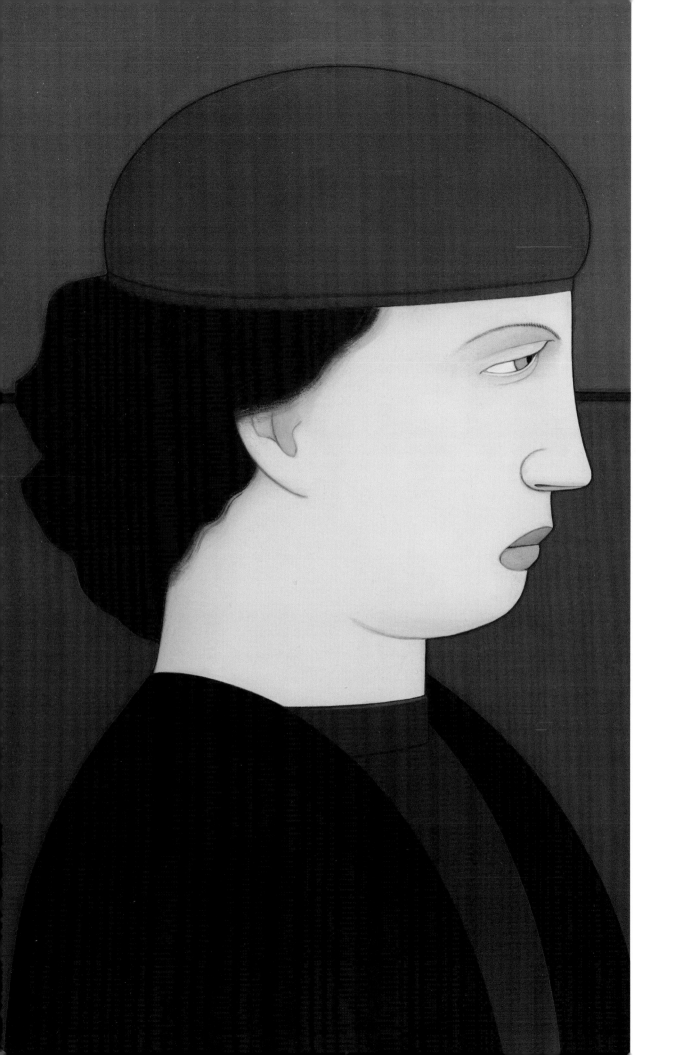

Works in Exhibition

Woman Wearing a Red Hat, 2014
Oil on linen, 16 x 10 inches

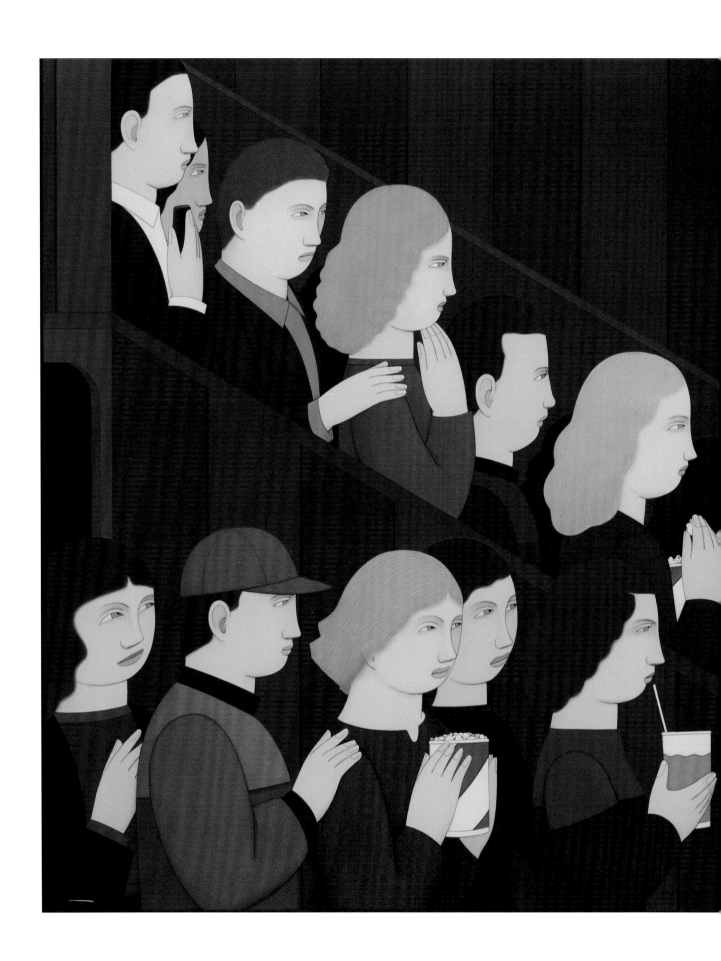

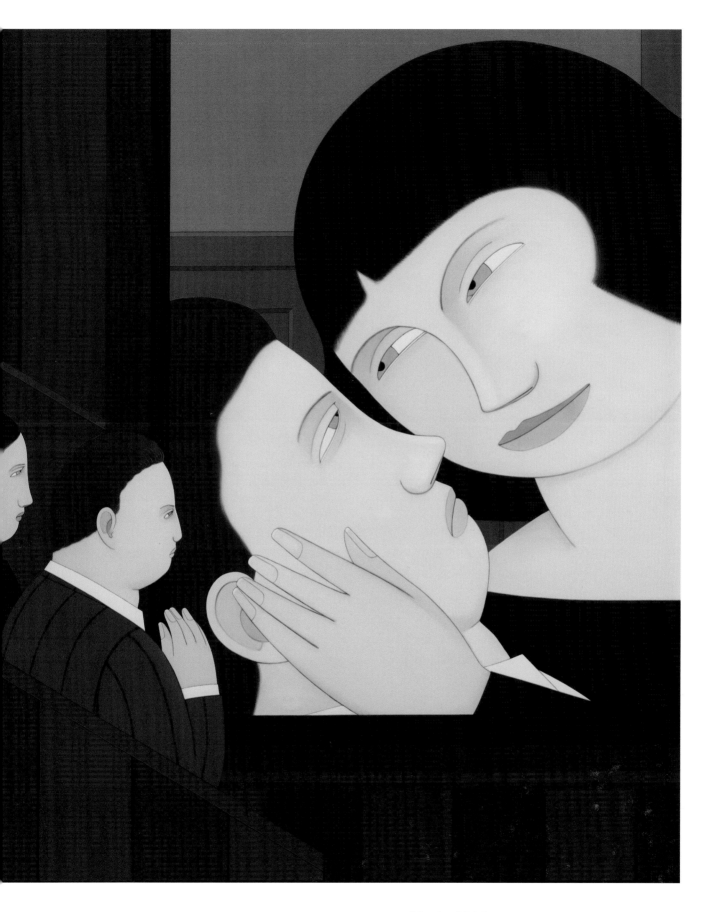

Movie, 2014
Oil on linen, 45 x 75 inches

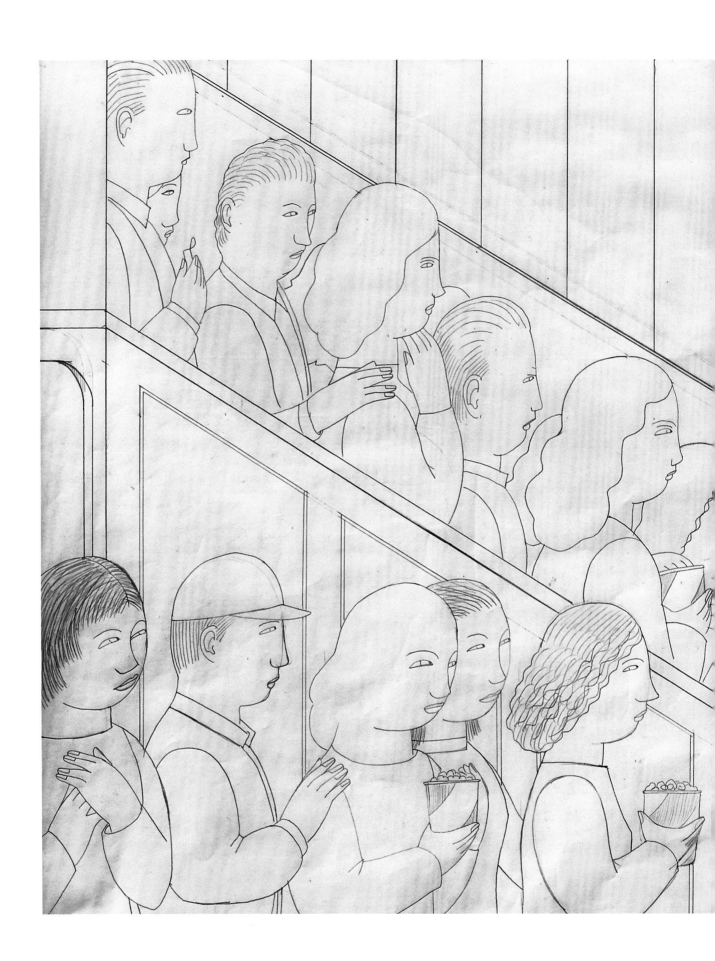

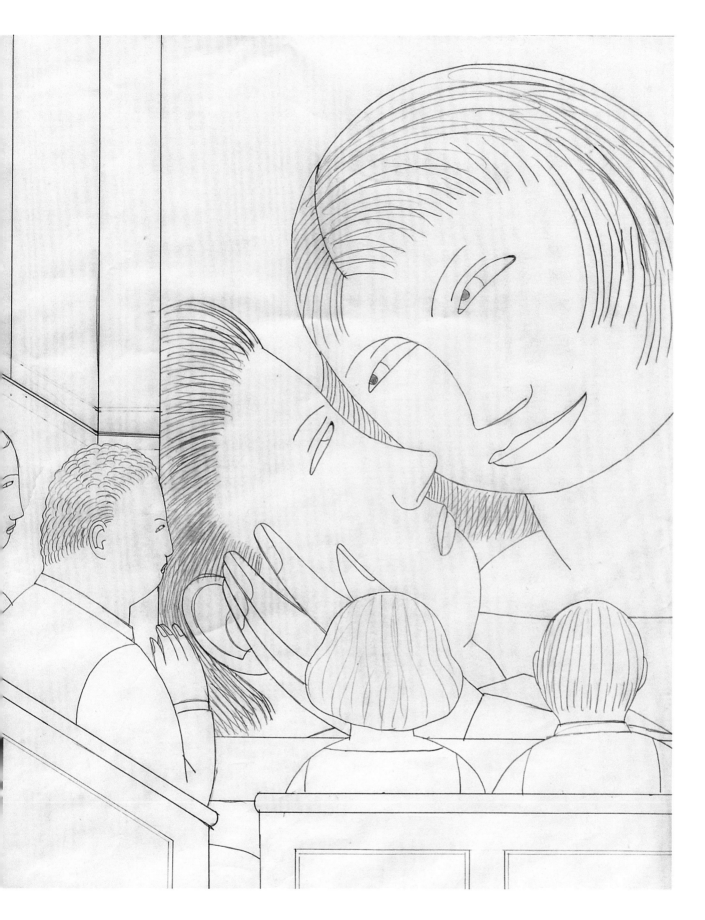

Movie, 2014
Pencil on paper, 24 x 40 inches

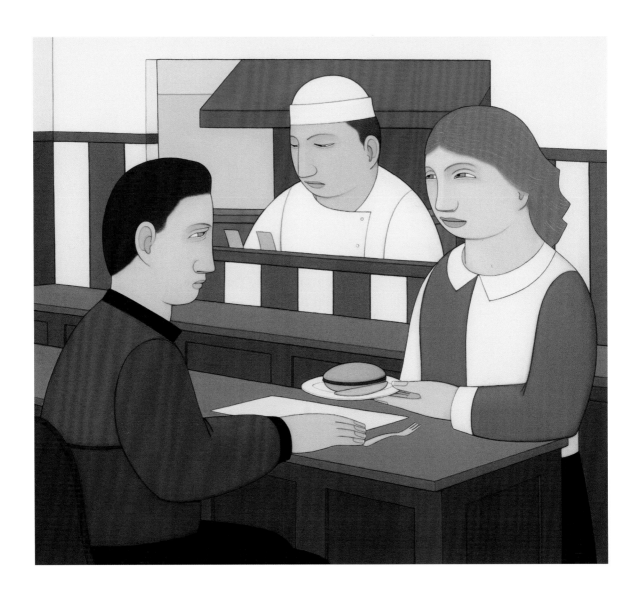

Above
Hamburger at Rosie's, 2011
Oil on linen, 16 x 18 inches

Right
Ollie's Pizza, 2010
Oil on linen, 16 3/4 x 12 inches

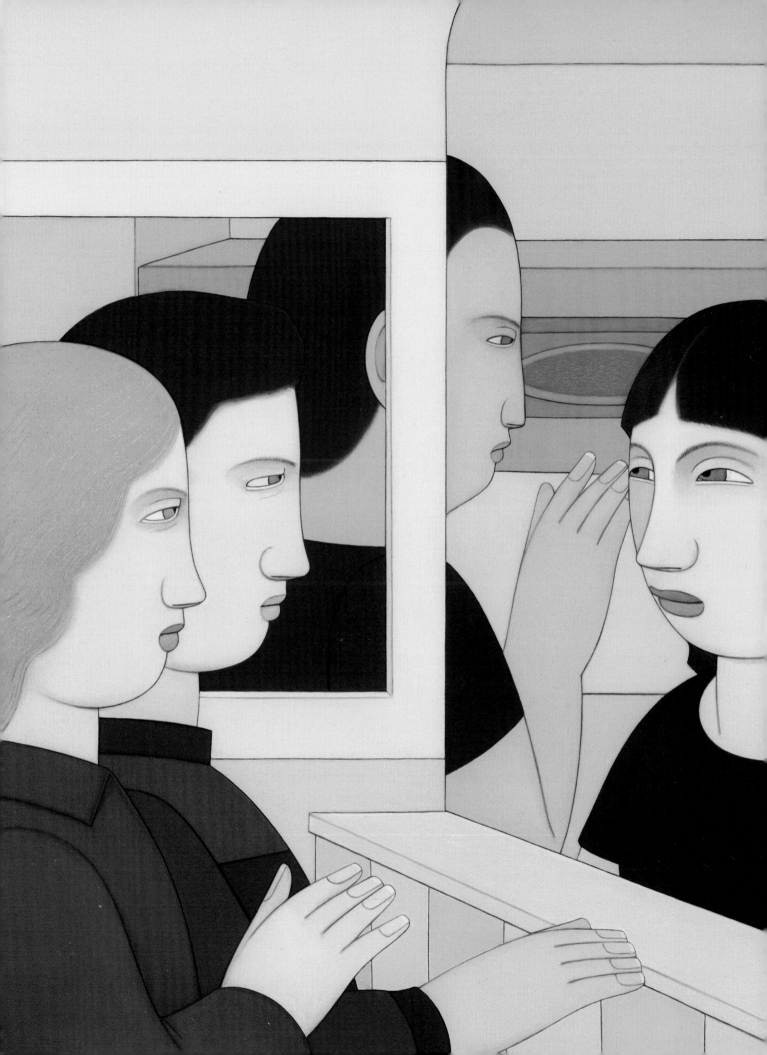

Lola Too (Transfer Drawing), 2014
Pencil on paper with pastel tone on reverse, 7 x 7 1/2 inches

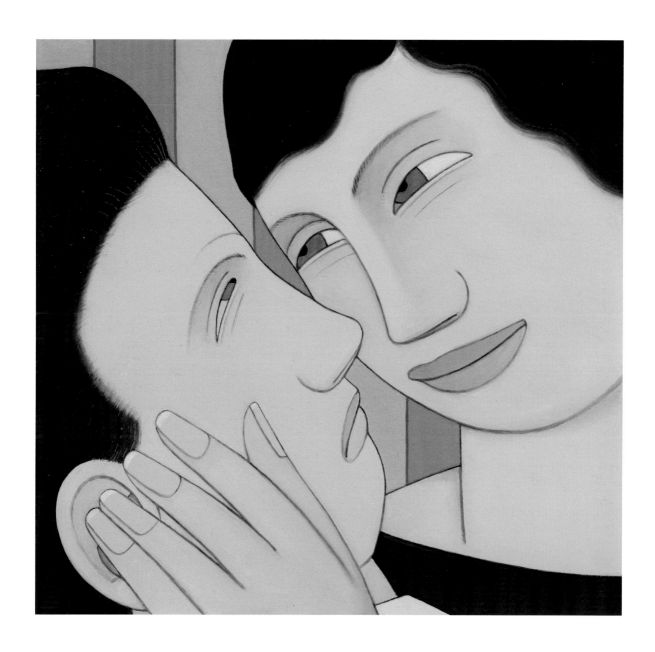

Lola Too, 2014
Oil on linen, 7 x 7 1/2 inches

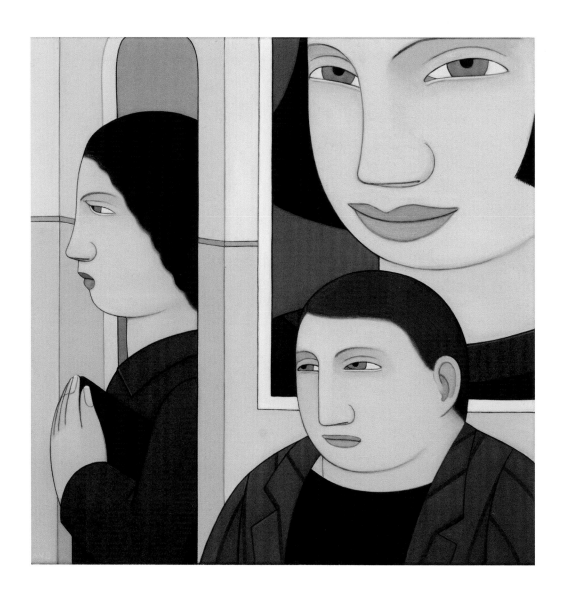

Subway: East Street Station, 2011
Oil on linen, 10 x 10 inches

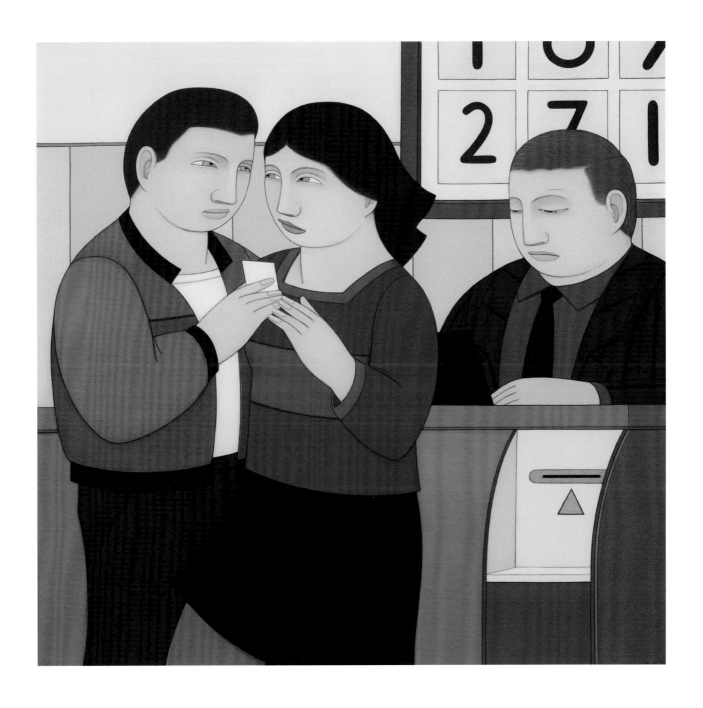

Number Game, 2011
Oil on linen, 20 x 20 inches

Following Page Spread
Blackjack Players, 2012
Oil on linen, 28 x 42 inches

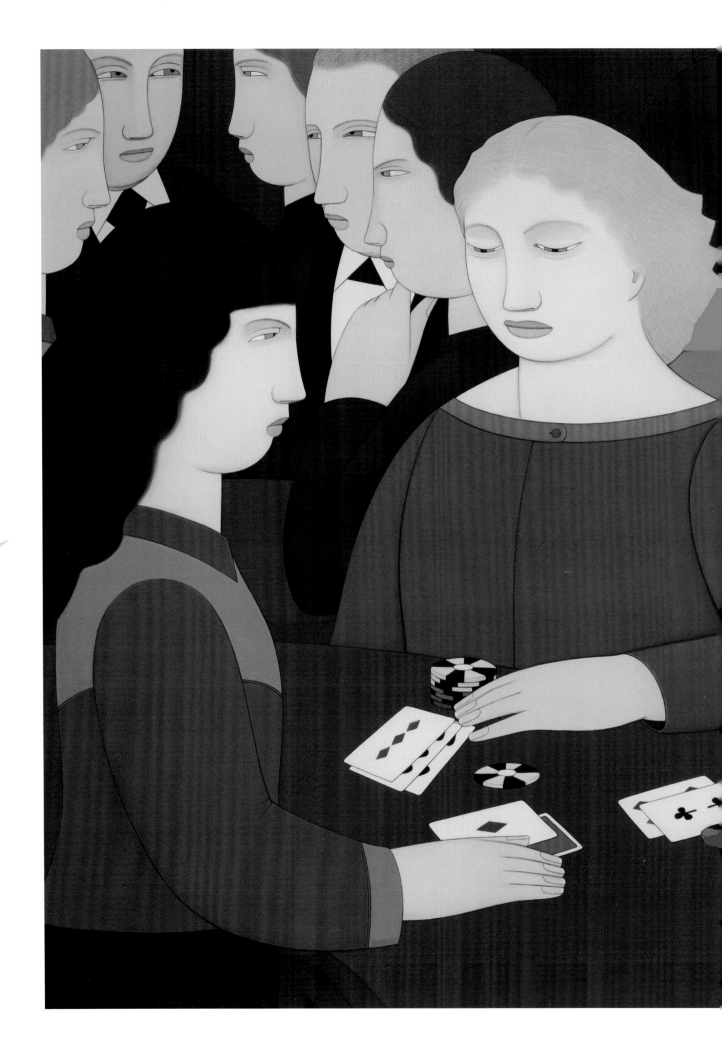

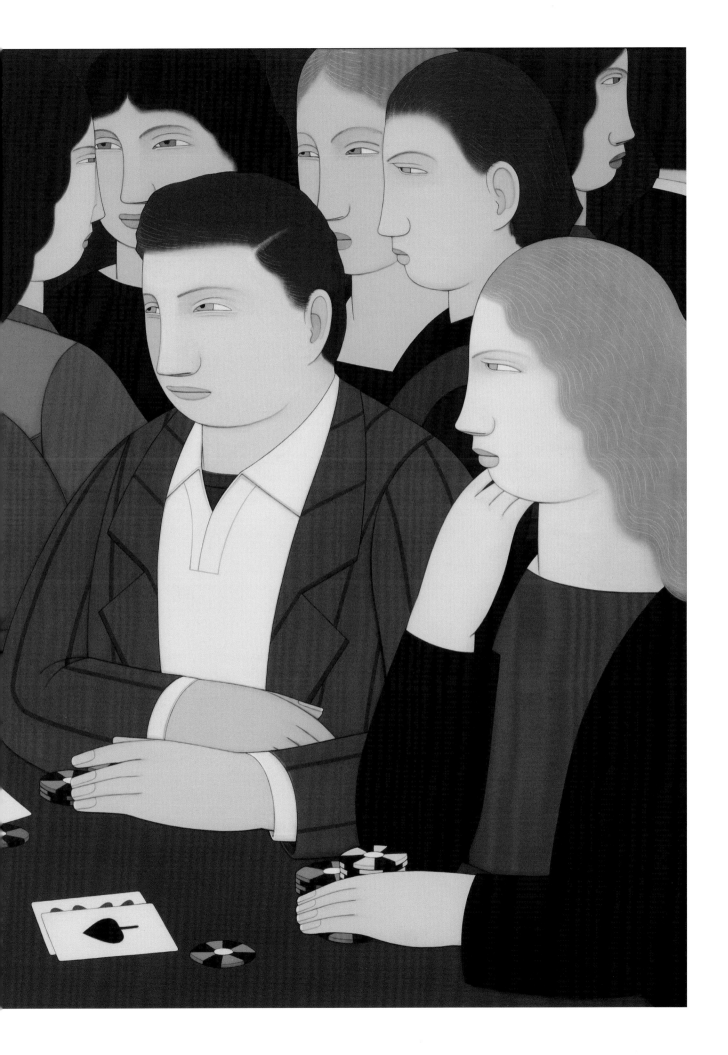

Cellphones (Transfer Drawing), 2012
Pencil on paper with pastel tone on reverse, 15 x 15 inches

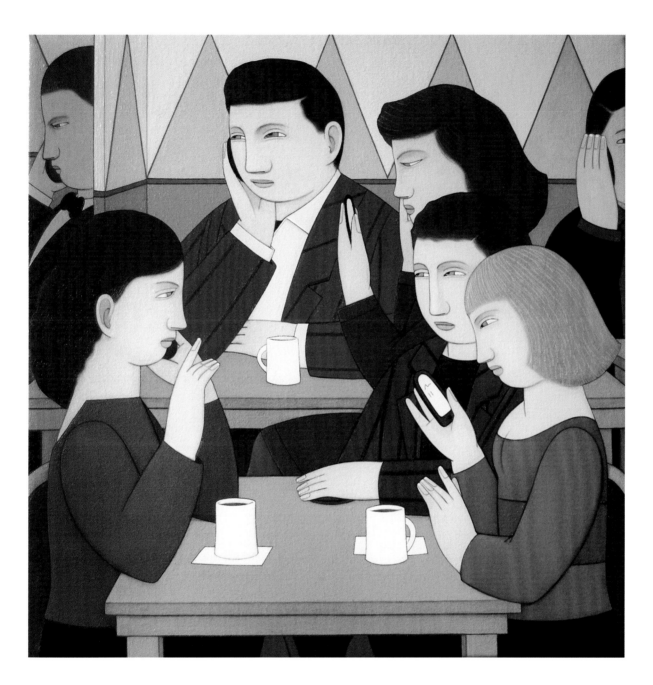

Cellphones, 2012
Oil on linen, 15 x 15 inches
Private collection, Massachusettes

Cellphone, Drawing #3, 2012
Pencil on graph paper, 7 1/4 x 9 inches

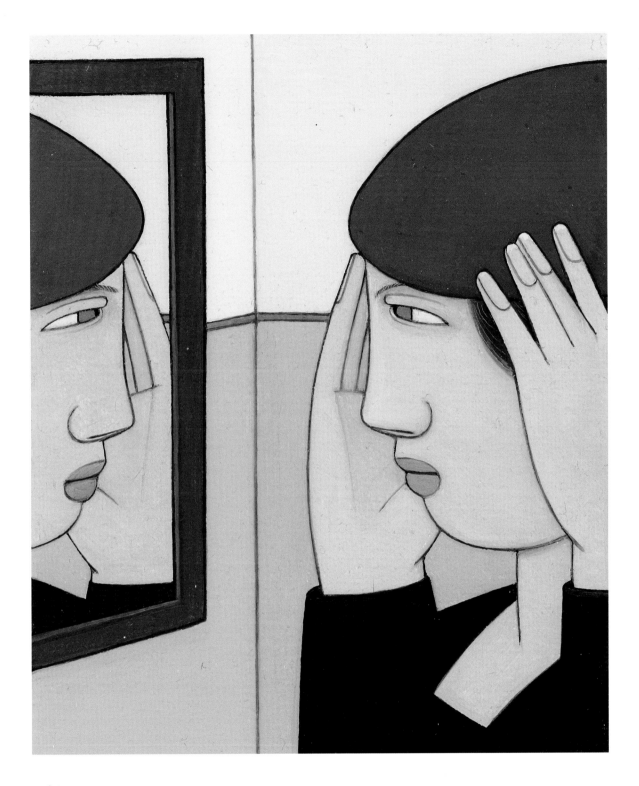

Red Beret, 2012
Oil on linen, 5 1/2 x 4 inches, 2012

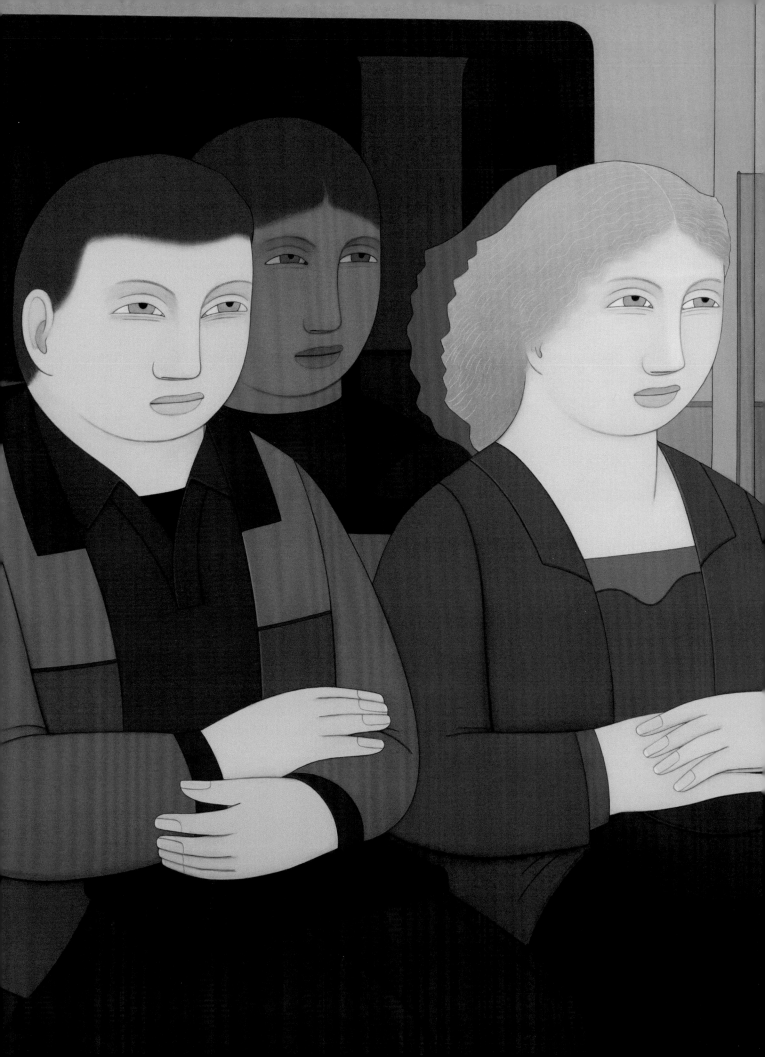

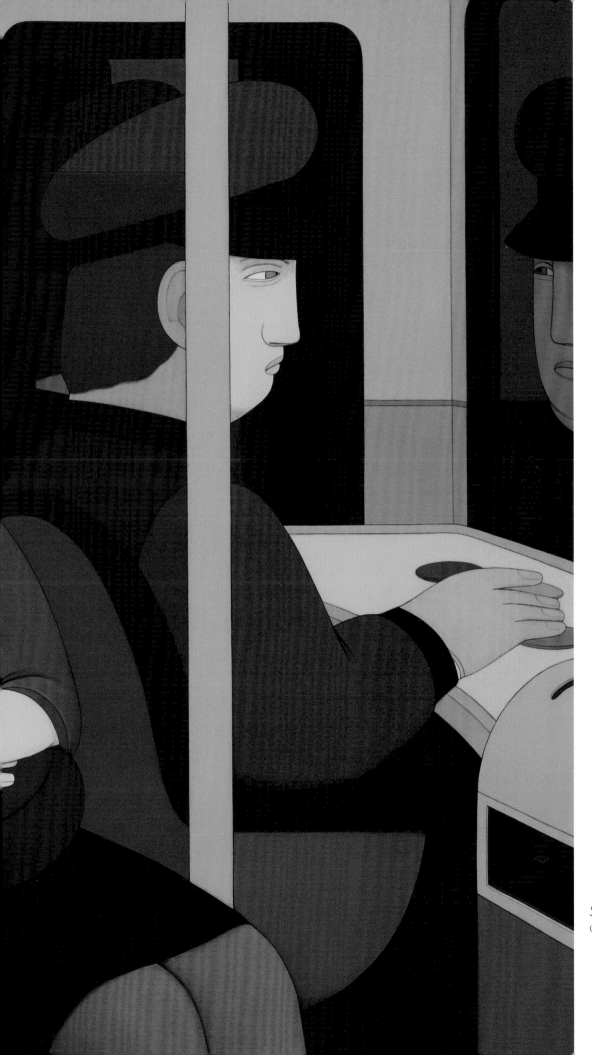

Subway Riders, 2014
Oil on linen, 30 x 40 inches

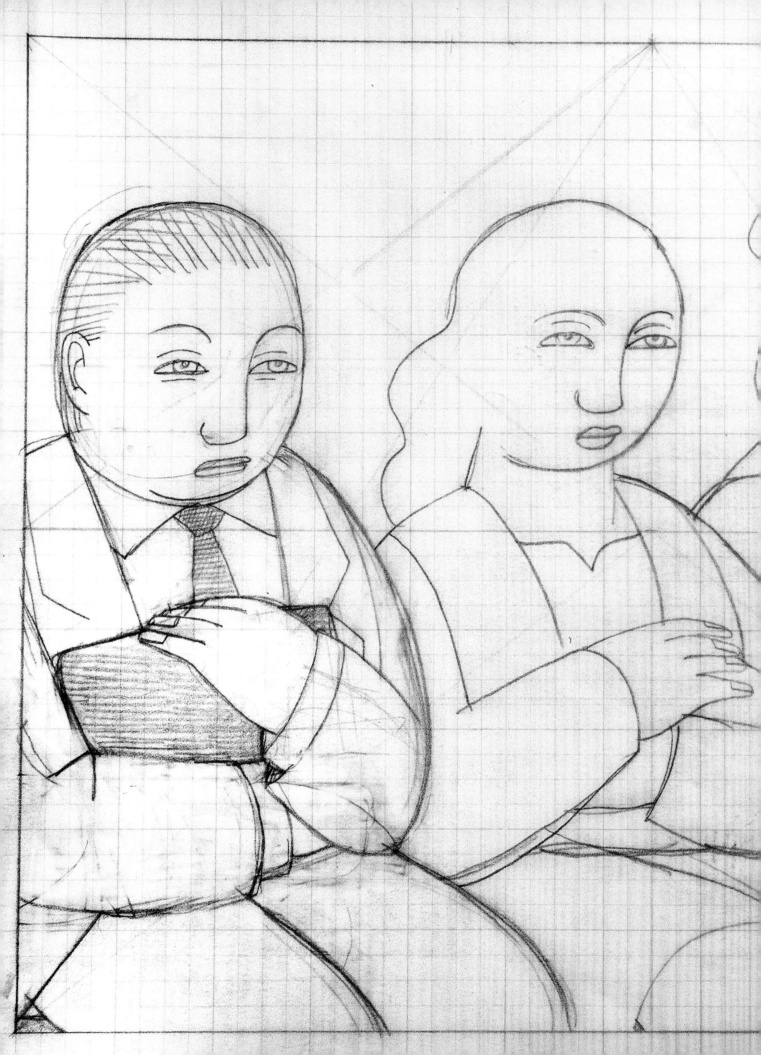

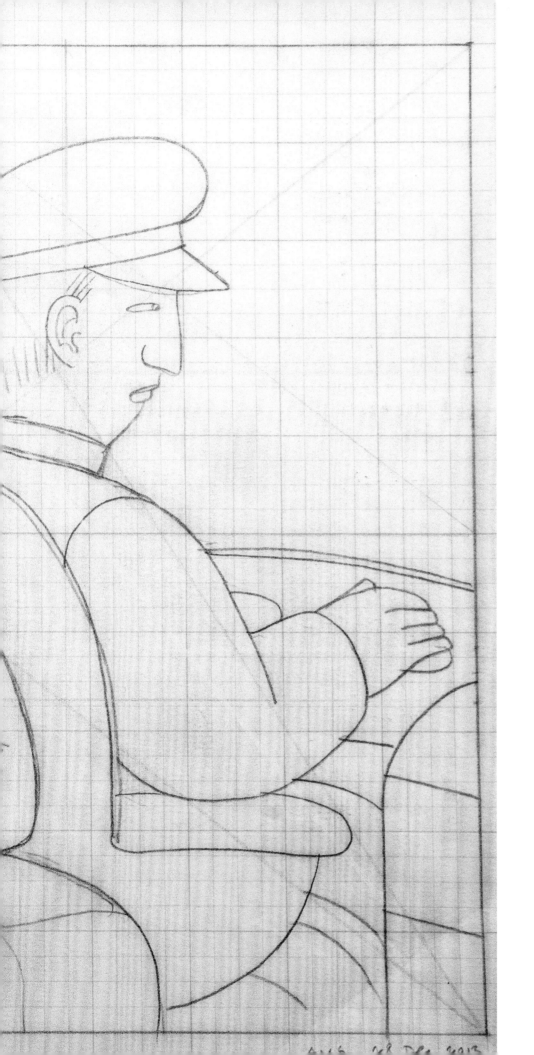

Subway Riders, Drawing, 2014
Pencil on graph paper, 10 x 13 inches

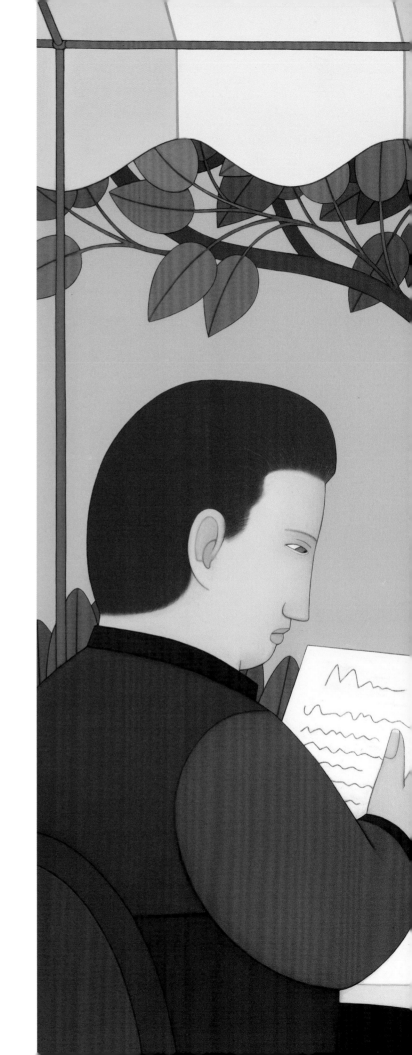

Lunch in Ithaca, 2011
Oil on linen, 27 x 30 inches

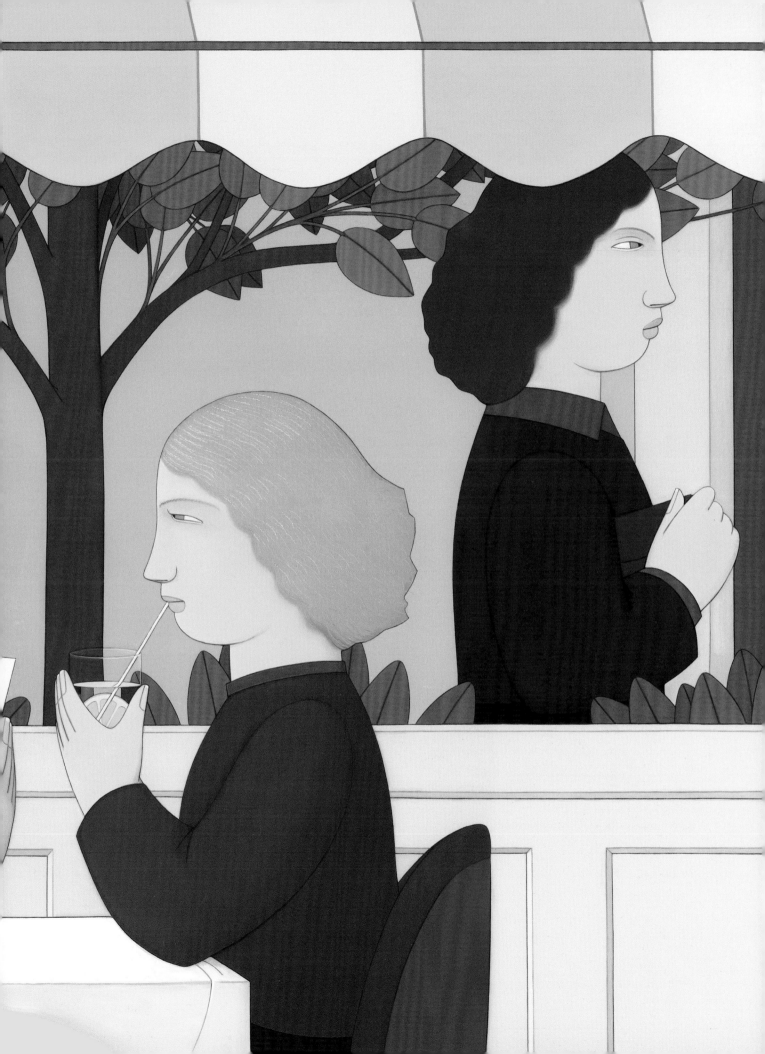

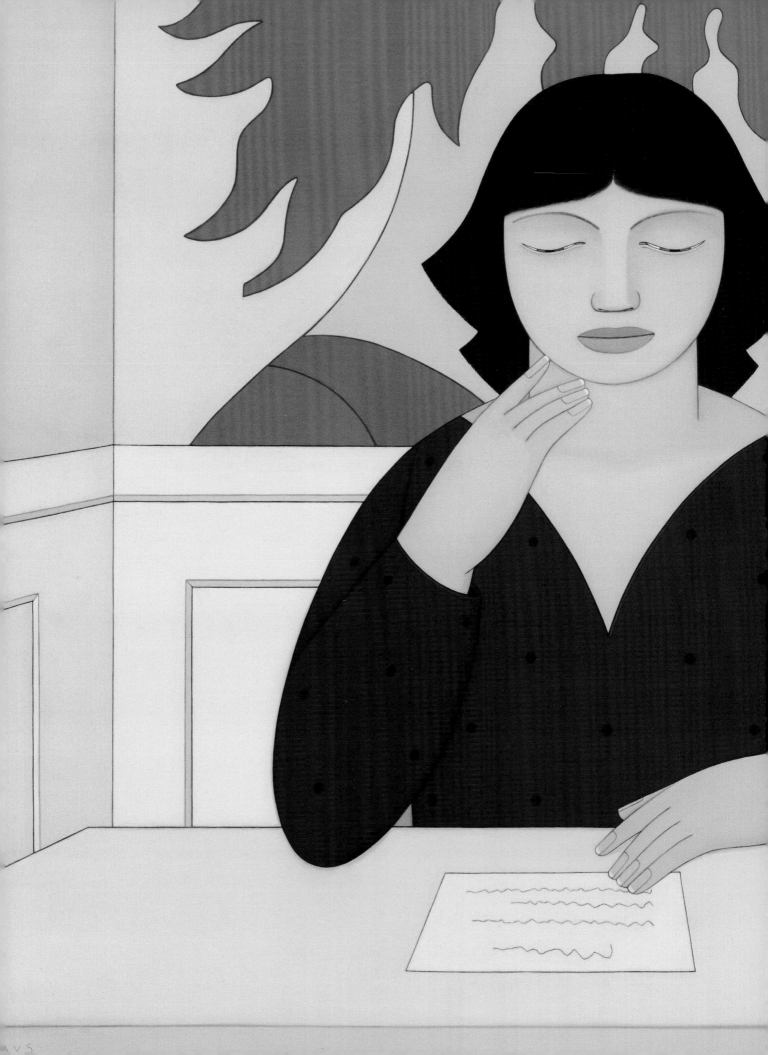

Dinner in Ithaca, 2011
Oil on linen, 25 x 30 inches

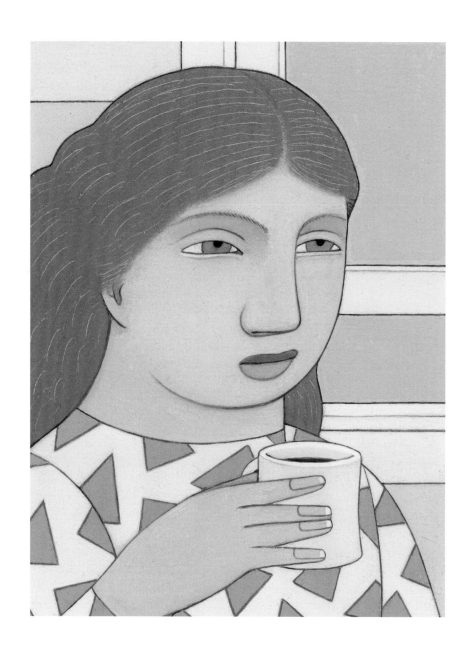

Coffee, 2012
Oil on linen, Diptych 6 x 4 1/2 inches each panel

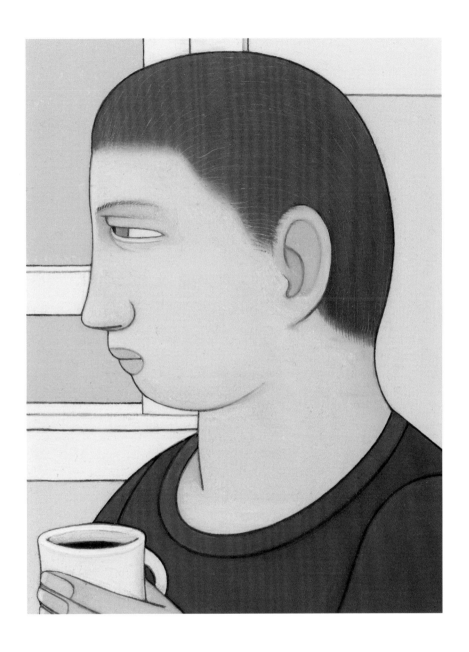

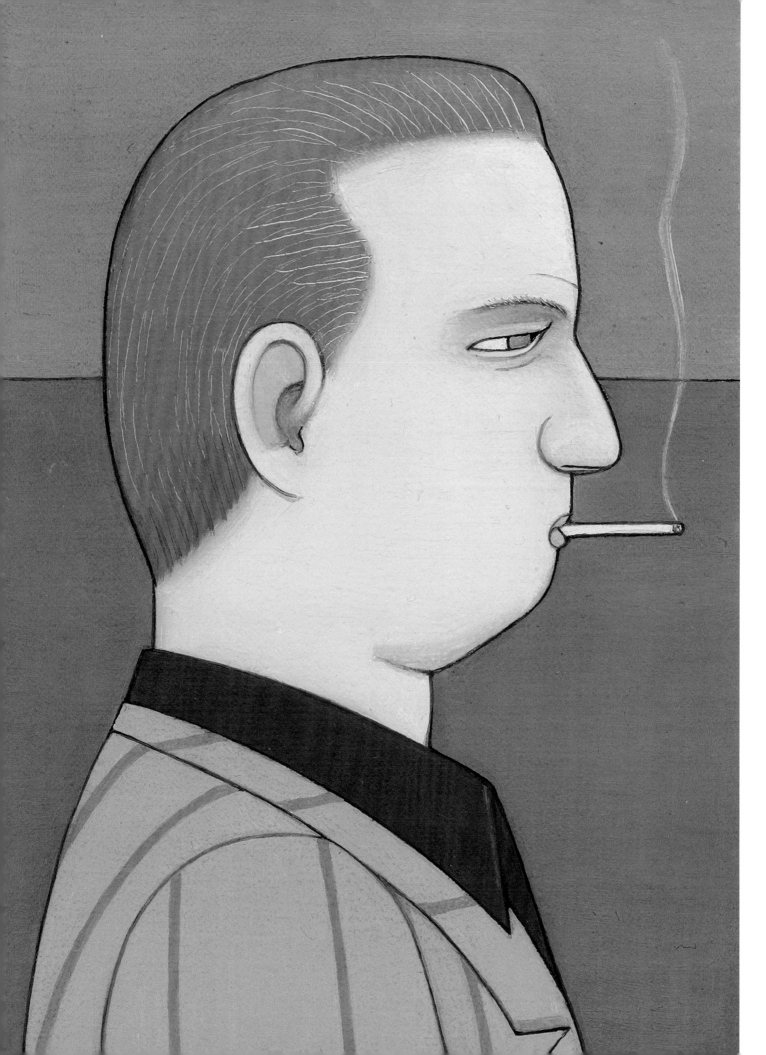

Left
Marko, 2013
Oil on linen, 6 1/4 x 4 1/2 inches

Above
Marko, Drawing #3, 2013
Pencil on graph paper, 5 1/2 x 4 inches

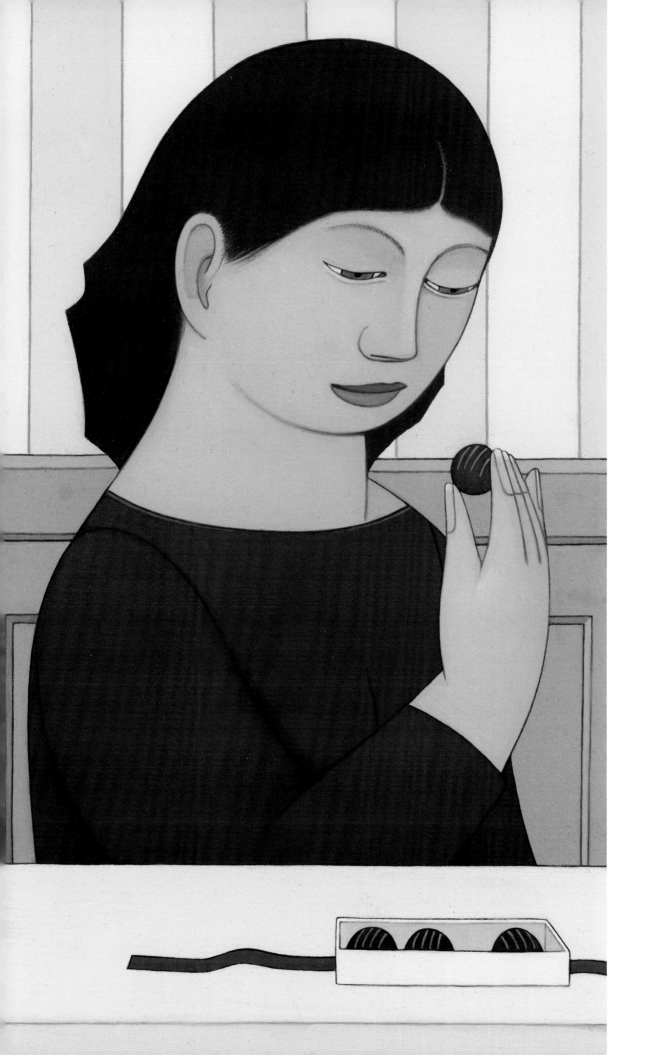

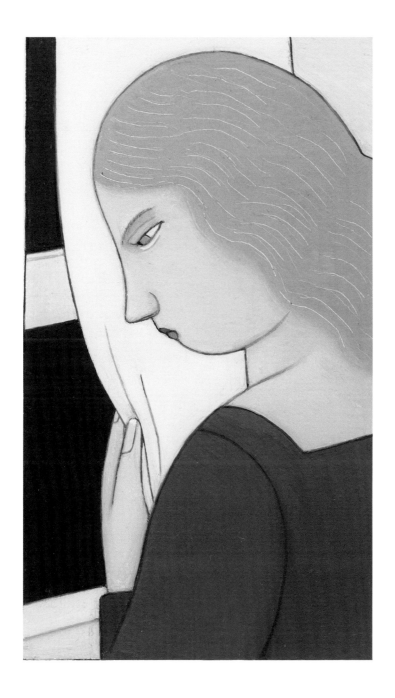

Left
Chocolate Truffles, 2013
Oil on linen, 12 x 7 1/4 inches

Above
Anne at the Window, 2013
Oil on linen, 5 1/4 x 3 inches

39

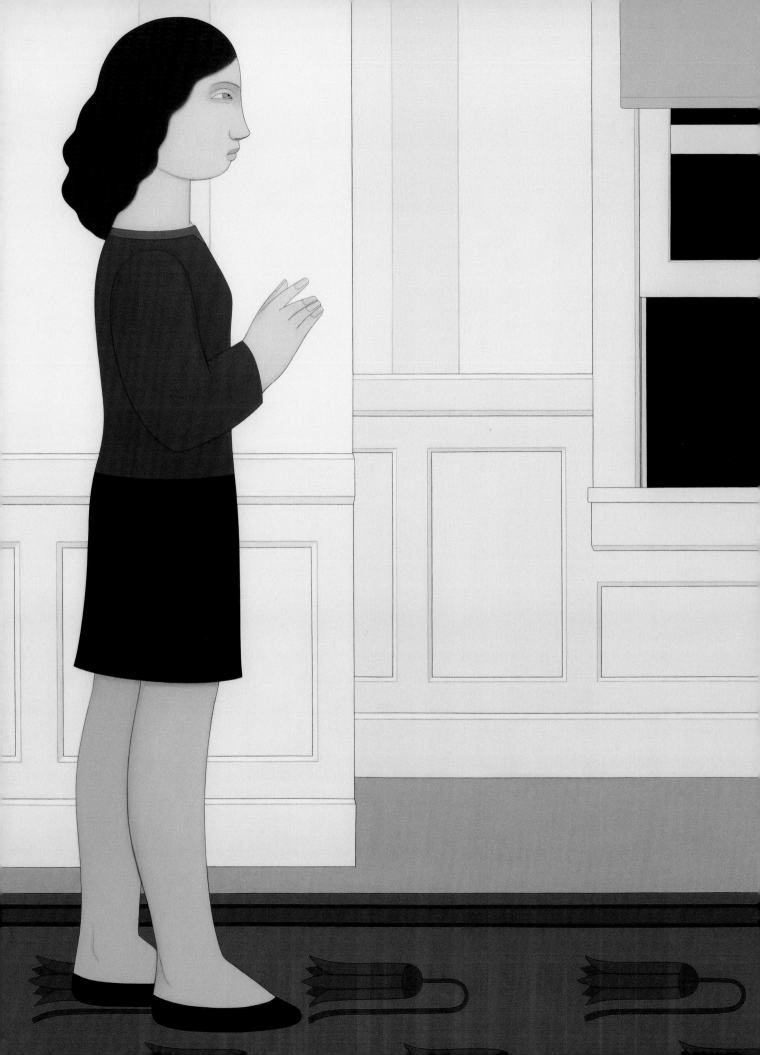

Interior at Night, 2013
Oil on linen, 52 x 50 inches

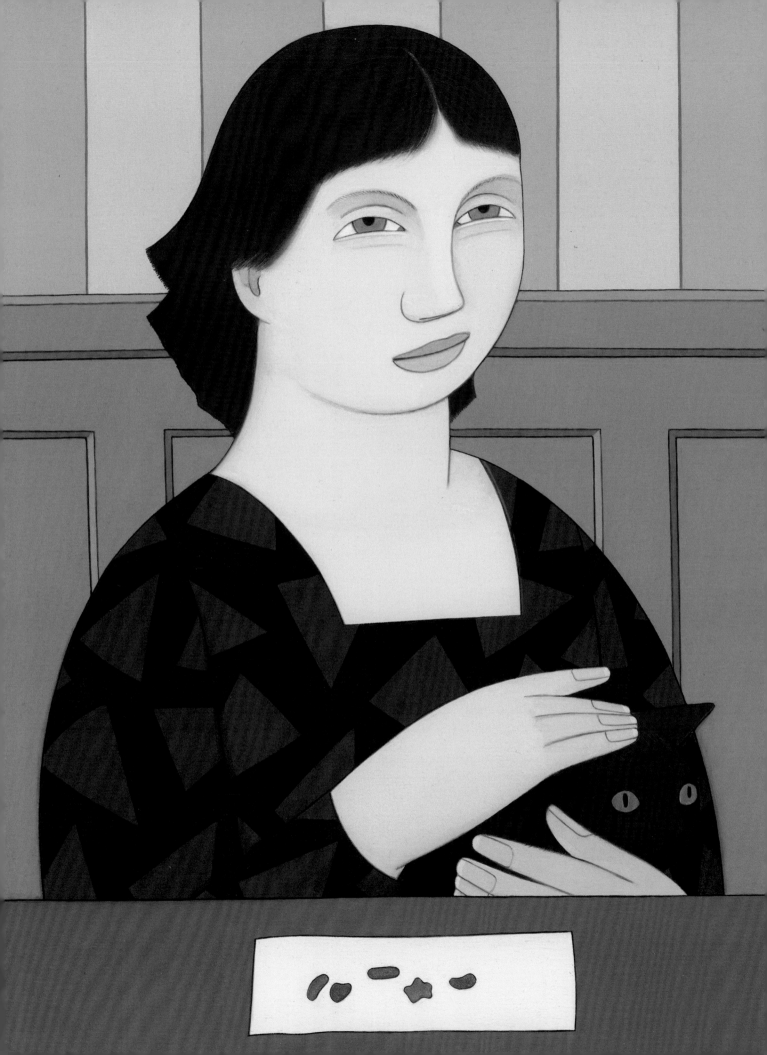

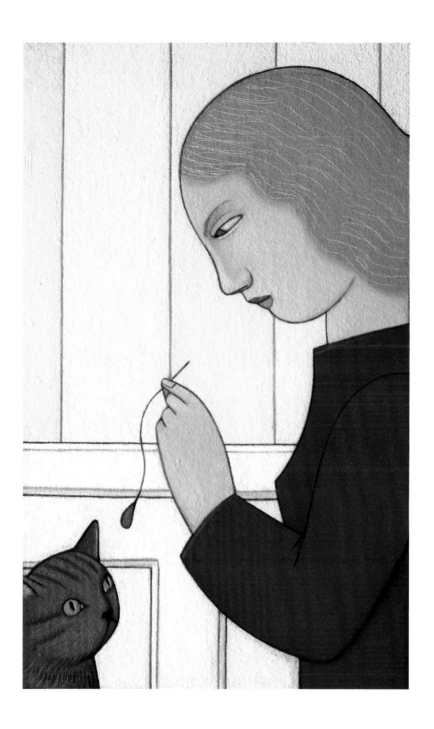

Left
Mr. Epps, 2014
Oil on linen, 16 x 12 inches

Above
Mookie, 2014
Oil on linen, 6 1/2 x 4 inches
Private collection, Maine

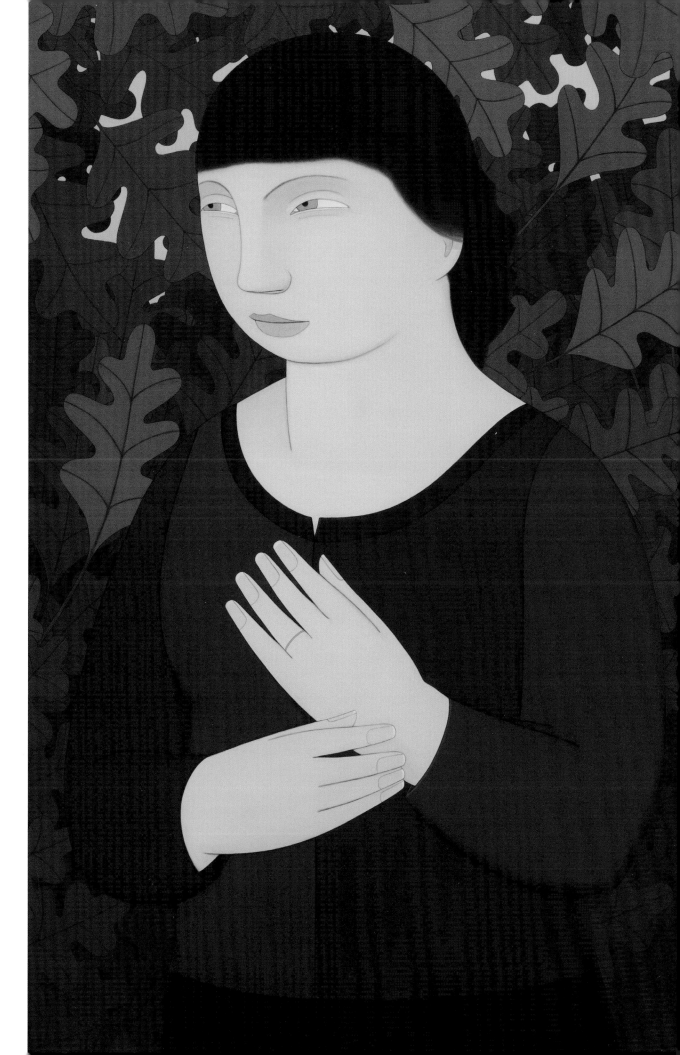

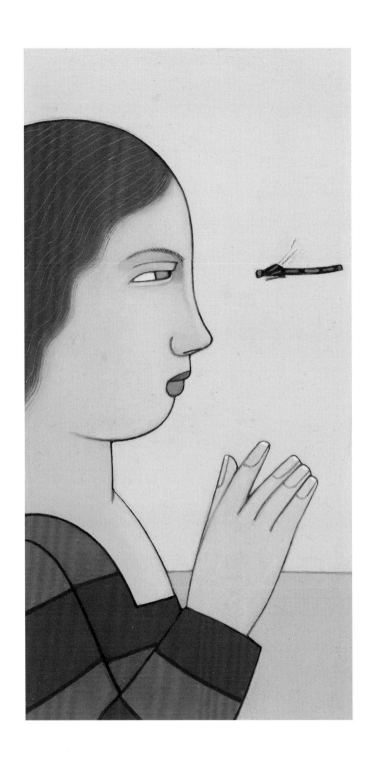

Dragonfly, 2014
Oil on linen, 6 1/2 x 3 1/4 inches
Private collection, Florida

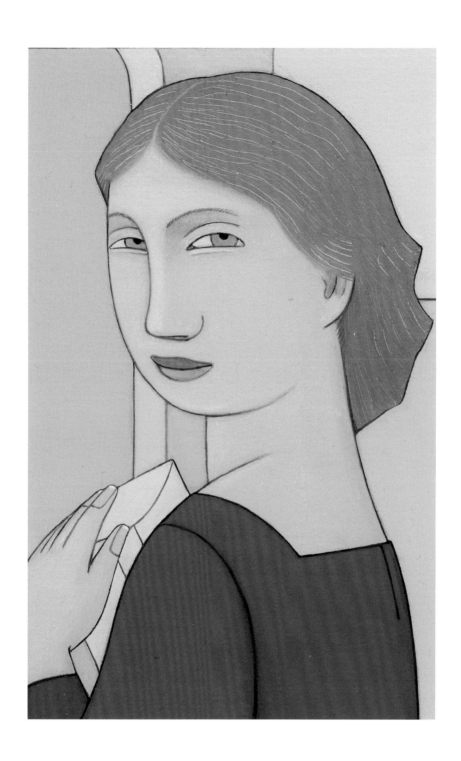

Woman with a Large Envelope, 2013
Oil on linen, 7 x 4 1/2 inches

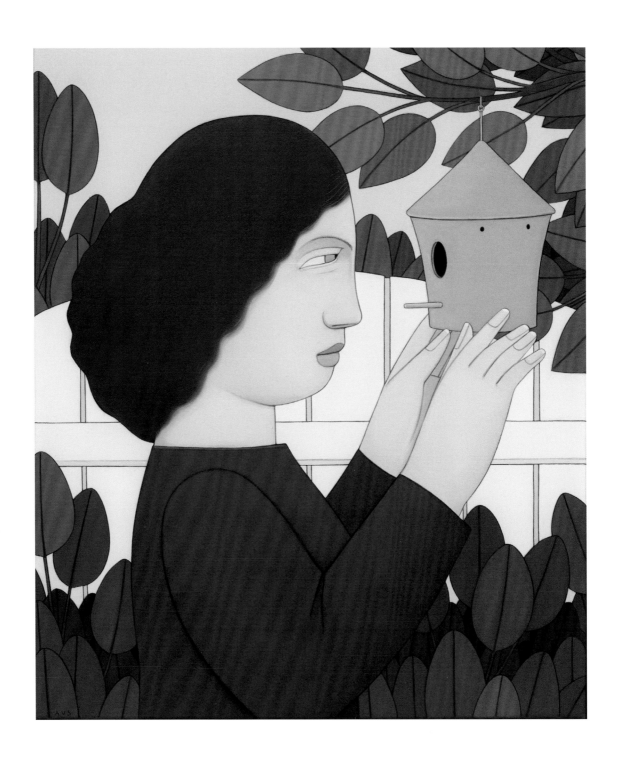

Heidi's Birdhouse, 2014
Oil on linen, 18 x 15 inches

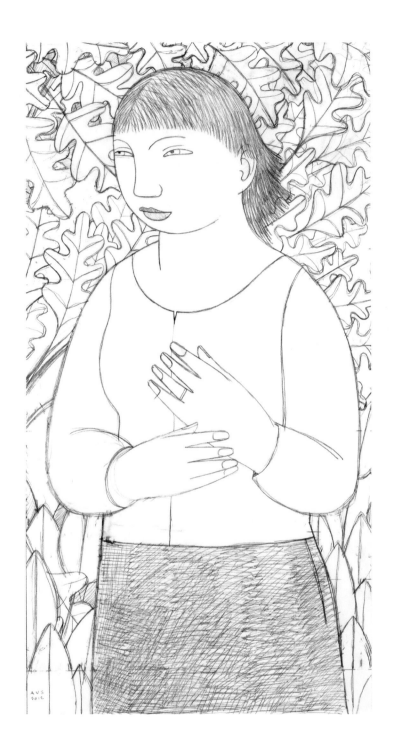

Sophie Drawing #2, 2012
Pencil on paper, 30 x 16 inches

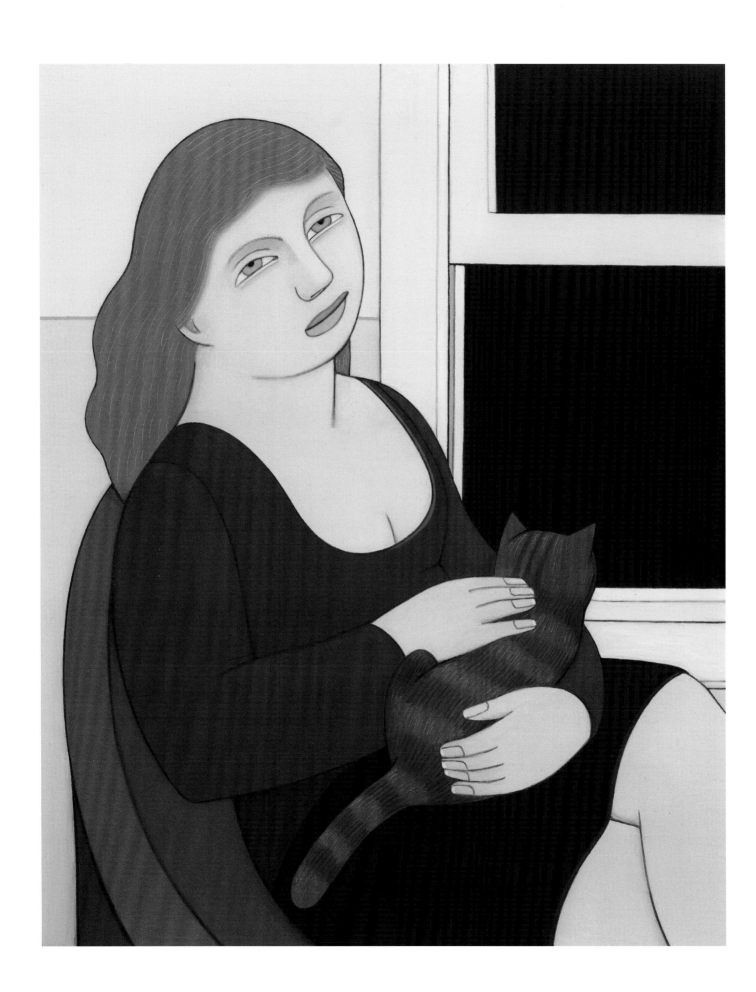

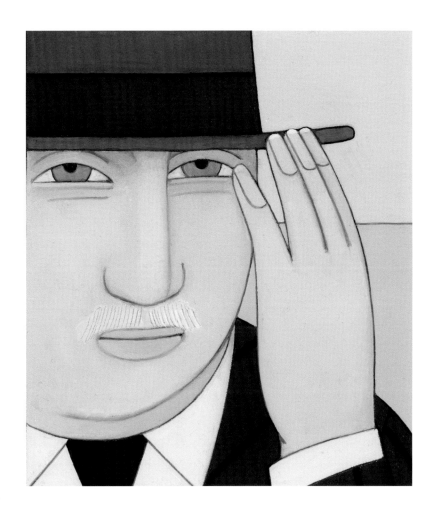

Woman with a Grey Cat, 2014
Oil on linen, 11 1/2 x 9 1/2 inches

Man Wearing a Grey Hat, 2014
Oil on linen, 4 3/4 x 4 1/4 inches

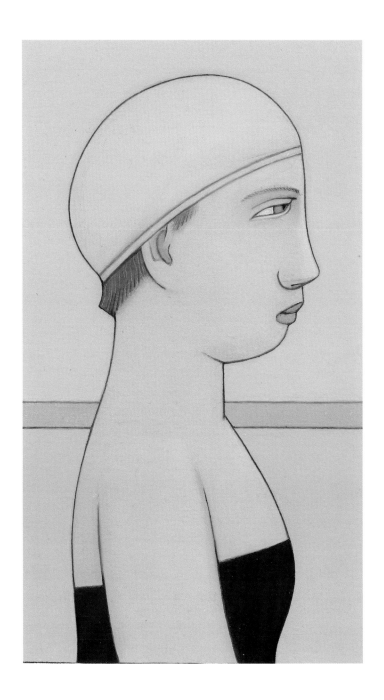

Nauset Beach, 2013
Oil on linen, 7 x 4 inches

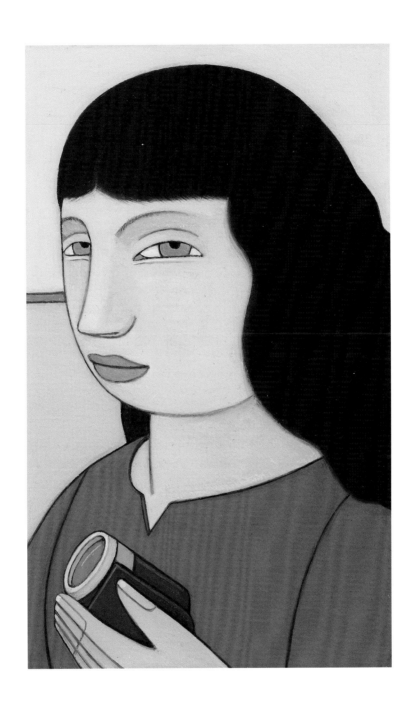

Woman with Camcorder, 2013
Oil on linen, 6 x 3 3/4 inches

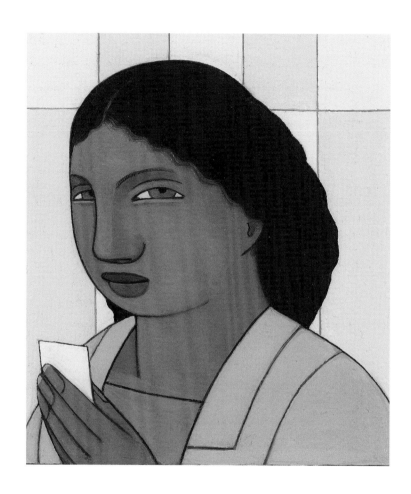

Suki with a Note, 2012
Oil on linen, 4 1/2 x 3 3/4 inches

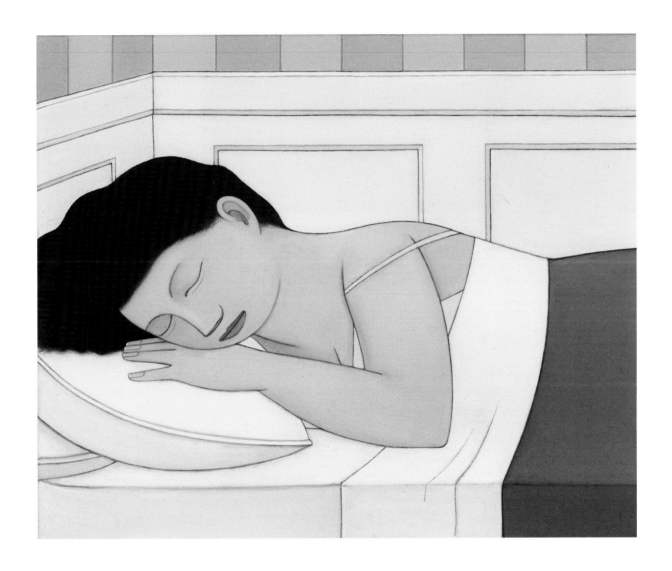

Loretta Sleeping, 2013
Oil on linen, 8 1/4 x 10 inches

Biography

Andrew Stevovich (b. 1948)

A noted contemporary figurative painter, Stevovich grew up in Washington, D.C. He spent time roaming the halls of the National Gallery of Art, where he was particularly drawn to the Renaissance paintings that would come to inform his work. His images depict ordinary men and women in everyday situations and locations — in restaurants and bars, at the beach, on public transportation — but they convey a sense of mystery, creating more questions than they answer.

Although Stevovich's paintings are set in the contemporary world, their crisp design, brilliant color and meticulous surface finishes recall the Renaissance works he loved as a child. He works in oil and pastel, and is also an accomplished printmaker and etcher. Stevovich holds degrees from the Rhode Island School of Design and the Massachusetts College of Art, and is represented in many important public and private collections. His work has been the subject of numerous solo exhibitions across the United States as well as abroad.

Selected Solo Exhibitions

Adelson Galleries, New York, 1992, 1995, 1999, 2001, 2004, 2007, 2010
Adelson Galleries Boston, 2012
Alpha Gallery, Boston, 1971, 1973, 1976, 1978
Boca Raton Museum of Art, Boca Raton, Florida 2009
Clark Gallery, Lincoln, Massachusetts, 1985, 1990, 1997, 1999, 2004, 2007
Clark University, Worcester, Massachusetts, 1980
Coe Kerr Gallery, New York, 1983, 1985, 1987, 1990
Danforth Museum of Art, Framingham, Massachusetts, 1999, 2007
Hudson River Museum, Yonkers, New York 2008 – 2009
Impressions Gallery, Boston, 1982
Loft Gallery, Huntsville, Alabama, 1999
Mitsukoshi Gallery, Ebisu, Tokyo, 1996
New Britain Museum of American Art, New Britain, Connecticut, 1975
Pisa Galleries, Tokyo, Japan, 1992
Tatistcheff-Rogers Gallery, Santa Monica, California, 1989, 1993
Terrence Rogers Fine Art, Santa Monica, California, 2000
Virginia Lynch Gallery, Tiverton, Rhode Island, 1992, 2002

Selected Group Exhibitions

Approaches to Narrative, DeCordova Museum, Lincoln, MA, 2007
Annual Salon Show, Clark Gallery, MA, 1993-2009
New Acquisitions, DeCordova Museum, Lincoln, MA, 2003
Treasure, Terrence Rogers Fine Art, Santa Monica, CA, 2002
Virginia Lynch: A Curatorial Retrospective, Rhode Island Foundation, Providence, RI, 2000
Figurative Works of Art, Virginia Lynch Gallery, Tiverton, RI, 2000
Twenty Prints from Fifty Boston Years: 1949-1999
(Collection of the Boston Public Library), MPG, Boston, MA, 1999
The Cutting Edge: A Short History of the Woodcut, Portland Museum of Art, ME, 1995
Self-aMUSEd: The Contemporary Artist as Observer & Observed, Fitchburg Art Museum, MA, 1993
Group Exhibition, Tatistcheff-Rodgers Gallery, Santa Monica, CA, 1991
Recent Acquisitions, Portland Museum of Art, ME, 1991
Group Exhibition, Virginia Lynch Gallery, 1991, 1993
Contemporary Paintings, Coe Kerr Gallery, NY 1990
The Art of Love, Riverside Art Museum, CA, 1990
Common Roots/Diverse Objectives: Rhode Island School of Design
Alumni in Boston, Fuller Art Museum, Brockton, MA, 1989
Art/L.A., Los Angeles, 1989
The Art of Printmaking, Fitchburg Art Museum, MA, 1988,
and the Galerie Kunst in Turm, Kleve, Germany, 1989
Modern Works on Paper, Fergus-Jean Gallery, Columbus, OH, 1988
20th Century American Realism from the Blum Collection,
Aetna Art Institute Gallery, Hartford, CT, 1988
Chicago International Art Exposition, Chicago, Illinois, 1988, 1987, 1985, 1984
Modern and Contemporary Paintings, Coe Kerr Gallery, New York, 1984
Bathers, Coe Kerr Gallery, New York, 1984
Contemporary Paintings, Gallery of Lancaster, PA, 1984
Realistic Directions, Zoller Gallery, Pennsylvania State University, 1983
American Realism, Coe Kerr Gallery, New York, 1983
20th Century American Art, Coe Kerr Gallery, NY 1982
American Realism, Coe Kerr Gallery, New York, 1982
20th Anniversary Exhibition, Corcoran Gallery of Art, Washington, D.C., 1981
Boston Artists' Work on Paper, Boston University Gallery, 1981
Brockton Triennial, Fuller Art Museum, 1978
New Talent, Marilyn Pearl Gallery, New York, 1977
Patron's Choice, DeCordova Museum, Lincoln, MA, 1976
Arita / Reichert / Stevovich, Woods-Gerry Art Gallery,
Rhode Island School of Design, Providence, RI, 1970
Home on the Range (West by East), Woods-Gerry Gallery,
Rhode Island School of Design, 1970
Open Painting, Providence Art Club, RI, 1970, 1969

Public Collections

Addison Gallery of American Art, Andover, Massachusetts
Boston Athenaeum
Boston Public Library
Corcoran Gallery of Art, Washington DC
Danforth Museum, Framingham, Massachusetts
DeCordova Museum, Lincoln, Massachusetts
Estonian Art Museum (Eesti Kuntstimuuseumi), Tallin, Estonia
Florence Griswold Musuem, Old Lyme, Connecicut
Fuller Art Museum, Brockton, Massachusetts
Hudson River Museum, Yonkers, New York
Museum of Fine Arts, Boston
New Britain Museum of American Art, New Britain, Connecticut
Portland Museum of Art, Portland, Maine

Checklist

Anne at the Window
Oil on linen, 5 1/4 x 3 inches, 2013

39

Cellphones
Oil on linen, 15 x 15 inches, 2012

23

Coffee
Oil on linen, Diptych 6 x 4 1/2 inches each panel, 2012

34

Dragonfly
Oil on linen, 6 1/2 x 3 1/4 inches, 2014

46

Heidi's Birdhouse
Oil on linen, 18 x 15 inches, 2014

48

Lola Too
Oil on linen, 7 x 7 1/2 inches, 2014

17

Lunch in Ithaca
Oil on linen, 27 x 30 inches, 2011

30

Marko
Oil on linen, 6 1/4 x 4 1/2 inches, 2013

36

Movie
Oil on linen, 45 x 75 inches, 2014

10

Nauset Beach
Oil on linen, 7 x 4 inches, 2013

52

Blackjack Players
Oil on linen, 28 x 42 inches, 2012

20

Chocolate Truffles
Oil on linen, 12 x 7 1/4 inches, 2013

38

Dinner in Ithaca
Oil on linen, 25 x 30 inches, 2011

32

Hamburger at Rosie's
Oil on linen, 16 x 18 inches, 2011

14

Interior at Night
Oil on linen, 52 x 50 inches, 2013

40

Loretta Sleeping
Oil on linen, 8 1/4 x 10 inches, 2013

55

Man Wearing a Grey Hat
Oil on linen, 4 3/4 x 4 1/4 inches, 2014

51

Mookie
Oil on linen, 6 1/2 x 4 inches, 2014

43

Mr. Epps
Oil on linen, 16 x 12 inches, 2014

42

Number Game
Oil on linen, 20 x 20 inches, 2011

19

Ollie's Pizza
Oil on linen, 16 3/4 x 12 inches, 2010

15

Sophie
Oil on linen, 42 x 27 inches, 2012

45

Suki with a Note
Oil on linen, 4 1/2 x 3 3/4 inches, 2012

54

Woman Wearing a Red Hat
Oil on linen, 16 x 10 inches, 2014

8

Woman with a Large Envelope
Oil on linen, 7 x 4 1/2 inches, 2013

47

Red Beret
Oil on linen, 5 1/2 x 4 inches, 2012

25

Subway: East Street Station
Oil on linen, 10 x 10 inches, 2011

18

Subway Riders
Oil on linen, 30 x 40 inches, 2014

26

Woman with a Grey Cat
Oil on linen, 11 1/2 x 9 1/2 inches, 2014

50

Woman with Camcorder
Oil on linen, 6 x 3 3/4 inches, 2013

53

--------------------------- Drawings ---------------------------

Cellphones (Transfer Drawing)
Pencil on paper with pastel tone on reverse, 15 x 15 inches, 2012

22

Lola Too (Transfer Drawing)
Pencil on paper with pastel tone on reverse, 7 x 7 1/2 inches, 2014

16

Movie
Pencil on paper, 24 x 40 inches, 2014

12

Subway Riders, Drawing
Pencil on graph paper, 10 x 13 inches, 2014

28

Cellphone, Drawing #3
Pencil on graph paper, 7 1/4 x 9 inches, 2012

24

Marko, Drawing #3
Pencil on graph paper, 5 1/2 x 4 inches, 2013

37

Sophie Drawing #2
Pencil on paper, 30 x 16 inches, 2012

49

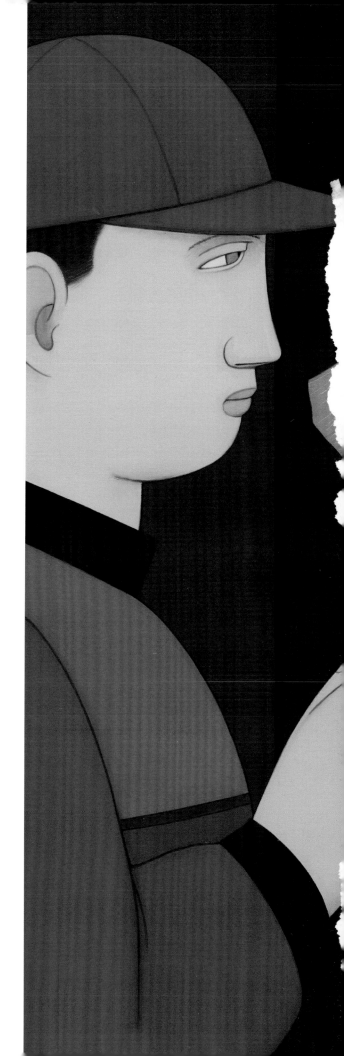

Published on the occasion of the exhibition

Andrew Stevovich: Familiar Faces

Boston:
February 6th - March 15th, 2015
New York:
March 24th - April 25th, 2015

Adelson Galleries
The Crown Building
730 Fifth Avenue, 7th Floor
New York, NY 10019
212.439.6800
adelsongalleries.com

Adelson Galleries Boston
520 Harrison Avenue
Boston, MA 02118
617.832.0633
www.adelsongalleriesboston.com

ISBN: 978-0-692-36942-5
Designed by Alexander Stevovich - Transomnebulism
Photography by Stewart Clements, Hubbard Toombs
Printed by GHP, West Haven, Connecticut

ADELSON GALLERIES

Cover:
Subway Riders (Detail), 2014, Oil on linen, 45 x 75 inches
Front Inside Cover & Back Inside Cover:
Movie (Detail), 2014, Oil on linen, 45 x 75 inches